DESTINATION
BARCELONA
BARCELONE

TECTUM
PUBLISHERS

DESTINATION
BARCELONA

© 2011 Tectum Publishers
Nassaustraat 40-42
2000 Antwerp
Belgium
info@tectum.be
+ 32 3 226 66 73
www.tectum.be

ISBN: 978-94-61580-30-6
WD: 2012/9021/03
(157)

No part of this book may be reproduced in any form, by print, photo print,
microfilm or any other means without written permission from the publisher.

Printed in China.

BARCELONE

La Sagrada Familia

9

17

Alleys

10.332 Taxis

La Rambla

33

La Boqueria

"Barcelona is a lover's kiss
A passion for life and beauty
A stroll down La Rambla
A long evening meal with old friends
A child's laugh as water
From a mosaic iguana runs across her fingers"

Excerpt froom "Barcelona - A Love Poem" by Charles Griffin

Near Parc Güell

Parc Güell

53

Mount Tibidabo

City view

65

"Tot el camp
és un clam
som la gent blaugrana
tant se val d'on venim
si del sud o del nord
ara estem d'acord
estem d'acord
una bandera ens agermana
Blaugrana al vent
un crit valent
tenim un nom que el sap tothom
BARÇA, BARÇA, BARÇA !! "

'Cant del Barça' clubsong from football club FC Barcelona

Nou Camp

81

Castellers

Santa Eulàlia Church

87

La Mercè

89

Via Laietana
Pl. Sant Jaume →
Ajuntament →
Palau de la Generalitat →
Museu Marès →
Museu d'Història de la Ciutat →

Antoni Tàpies Museum

Parc del Laberint

105

Casa Milà "La Pedrera"

"Blood on his torn glossy pants.
But the bull is down.
Brave, holding up the bull's ear,
he walks nearly falling.
The bright splash of people fumble in their cheering.
He makes a blunt move forward, out of the oval of shade.
But the bull gets up and comes from behind."

Excerpt froom "The Wounded Bullfighter" by Clarence Major

Bullfight Arena

GANADERIA GARCIGRANDE

SALIDA	NACIMIENTO	PESO
2º	9-04	539

Castell de Montjüich

Museu Nacional de Cata

unya

133

Magical Fountain

Palau Sant Jordi

Calatrava Tower

Teleferic

143

Port Vell

147

Colombus statue

Casa Batlló

159

161

Sunset

173

"one earth full of single stars
blown here by unrelenting years
those seas of sorrows know
written in liars lines
saying
come and become the past
full like her darkest pity
to show
such thought is mine"

Excerpt froom "A Poem for Barcelona" by B.Hetherington,

Gothic Quarter

Plaza Reial

Gargoyle

Parc De la Ciutadella

195

Macba Museum

NTEMPORANI DE BARCELONA

Barceloneta

209

Barcelona at night

213

Teatre Nacional de Catalunya

Plaza Espanya

"Do not fall in love in Barcelona"

Found on the street in Barcelona,

Bars

TAPAS

SUPER "BOCATA" TORTILLA PATA
CALAMARES A LA ROMANA
RABAS 6'50€
PATATAS BRAVAS 4€
PULPITOS 5'50€
CROQUETAS 4'50€
BOQUERONES EN VINAGR
TORTILLA DE PATATAS 3'5
PULPO A LA GALLEGA 12
ALITAS DE POLLO BARBACO
ENCHILADAS 5'40€
QUESADILLAS 5'40€
XICANOS 5'90

PLEASE
NO SMOKING

Statues

ODA NOVA A BARCELONA JOAN MARAGALL

235

Arc de Triomf

Citylife

243

Museum Miro

251

Architecture

257

Parc Recerca Biomedica

"Plaça de Prim
rectangle square off Laberint
emptyish without weekday passers,
on the other bench an ancient
drawing Spanish heat
to a Dresden frame,
the day straight down;
beetle dress and shawl,
mantilla half head
white wisps peeping,
heavy mouth, jelly chin,
cheeks travel routes on a map,
eyes narrow and clapped
to a Sunday paper"

Excerpt from "Barcelona Grandmother" by John Flanagan

Night Life

271

Catalan Music Palace

The Maritime Museum

277

"Barcelona with its joie
Citizens trundle the
Young walk in concert
Sharing a bottle with

Excerpt froom "Barcelona" by Craig Parker

de vivre charm
denizen street
as light first appears
worlds that are theirs"

Rain

Old Train Station

Picasso Museum

Hospital de la Santa Creu

291

Torre Agbar

Roofs of Barcelona

297

Hot Spots

Restaurants

Alkimia	Indústria 79	www.alkimia.cat
Cal Pep	Pl. de les Olles, 8	www.calpep.com
Ca l'Isidre	Flors, 12	www.calisidre.com
Cinc Sentits	Aribau, 58	www.cincsentits.com
Comerç 24	Comerç, 24	
Con Gracia	Martinez de la Rosa 8	www.congracia.es
Els Pescadors	Plaça Prim, 1	
El Xiringito de Bogatell	Ronda Litoral Mar, 42	
El Quim	La Rambla, 91	
Vinya Roel	Villaroel, 190-192	www.vinya-roel.com

Shopping

A loja do gato preto - decoration	Av. Gran Vía, 75	www.alojadogatopreto.com
Arkitektura Design	Via Augusta, 185	www.arkitektura.es
Bershka	Av. Portal d'Angel	www.bershka.com
Camper	Carrer Elisebets, 11	www.camper.com
Calzedonia Swimwear	Av. Portal d'Angel, 7/ Carrer Cucurulla	
Custo	Calle Ferran, No. 7	www.custo-barcelona.com
Desigual fashion	Passeig de Gràcia, 47	www.desigual.net
La Manual Alpargatera Shoes	Avinyó, 7	www.lamanualalpargatera.com
La Gauche Divine Vintage	Passage de la pau, 7	
Massimo Dutti	www.massimodutti.com	www.massimodutti.com
Papabubble Handmade Sweets	Ample, 28	www.papabubble.com
Recdi8 design	Carrer Espaseria, 7	www.recdi8.com/uk
Undergorund Limits	Magdalenas, 9	www.undergroundlimits.com

Nightlife

7Sins Bar	Muntaner 7	www.7sinsbar.com
Alternative Pub Crawl Bar	Secret Location	
Betty Ford Bar	Joaquin Costa, 56	
La Terrrazza Nightclub	Poble Espanyol	www.laterrrazza.com
Sports Bar Rambles	La Rambla dels Caputxins 31	www.bcnsportsbar.com

Highlights

Barceloneta		
Caixaforum	Paseo del Prado, 36	obrasocial.lacaixa.es
Camp Nou		www.fcbarcelona.com/camp-nou
Casa Batlló	Passeig de Gràcia, 43	www.casabatllo.es
Catedral de Santa Eulàlia		www.catedralbcn.org
Chocolat Museum	Comerç, 36	www.pastisseria.com/en/PortadaMuseu
Cosmo Caixa	Teodor Roviralta, 47-51	www.fundacio.lacaixa.es
Fundació Antoni Tàpies	Aragó 255	www.fundaciotapies.org
Fundación Joan Miró	Parc de Montjuï	www.fundaciomiro-bcn.org
Hospital de la Sant Pau	Sant Antoni Maria Claret, 167	www.santpau.es
Montjuïc	Parc de Montjuïc	
Museu Marítim	Av. de les Drassanes	www.mmb.cat
Museu Nacional d'Art de Catalunya	Parc de Montjuïc	www.mnac.es
Musée Picasso	Montcada 15-23	www.museupicasso.bcn.es
Parc Güell		
Las Ramblas		
Santa Caterina Market	Av. Francesc Cambó, 16	www.mercatsantacaterina.net/
Sant Pau del Camp	Sant Pau, 99	www.sacred-destinations.com/spain/barcelona-sant-pau-del-camp